grab a blank

sketched

Robbie Orbie

Copyright © 2019 by Robbie Orbie All rights reserved. This book or anyportion thereof may not be reproduced or used in anymanner whatsoever without the express written permission ofthe publisher except for the use of brief quotations in a book review. Printed in the United States of America

As practice makes perfect, I cannot but make progress; each drawing one makes, each study one paints, is a step forward.
Vincent Van Gogh

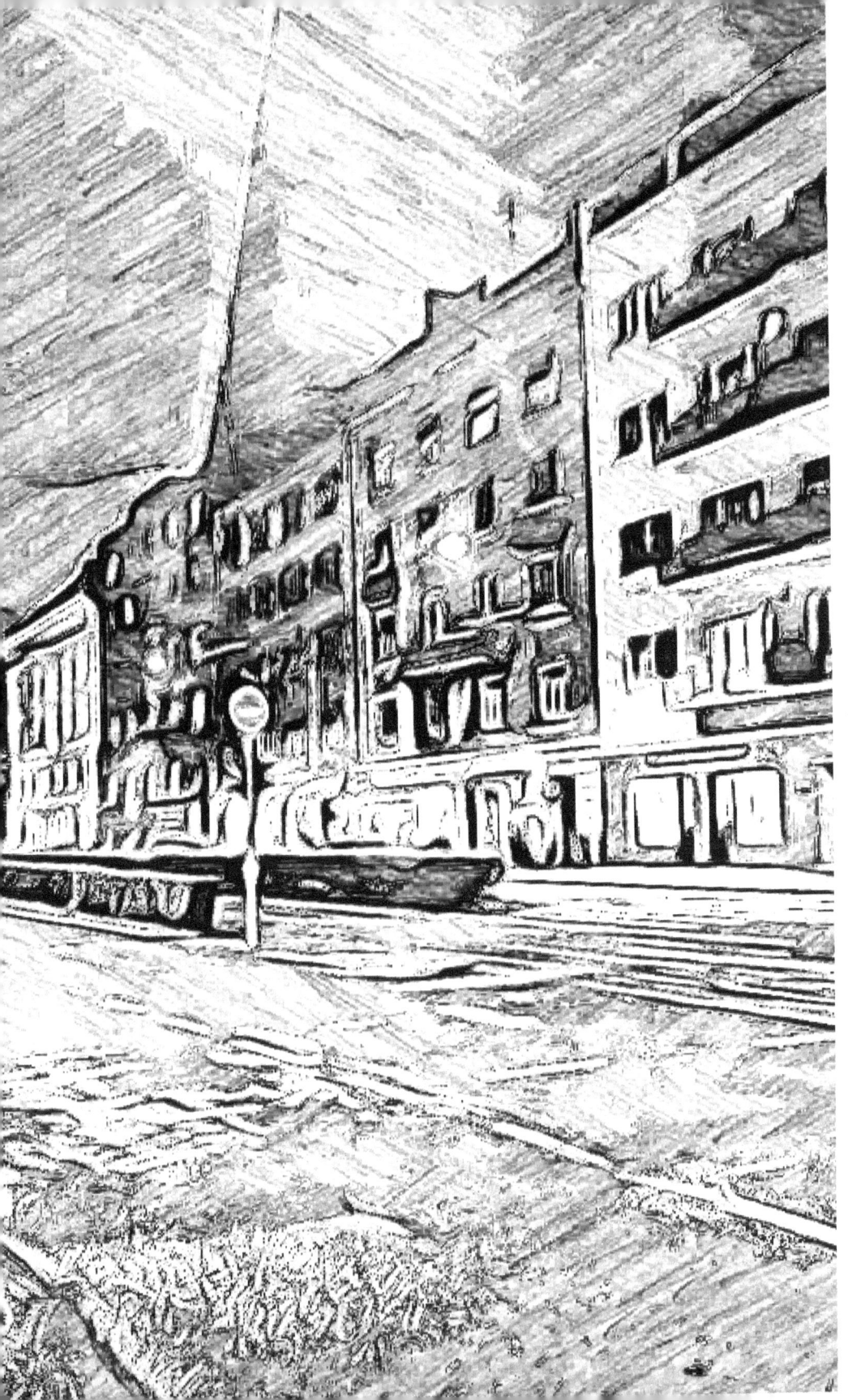

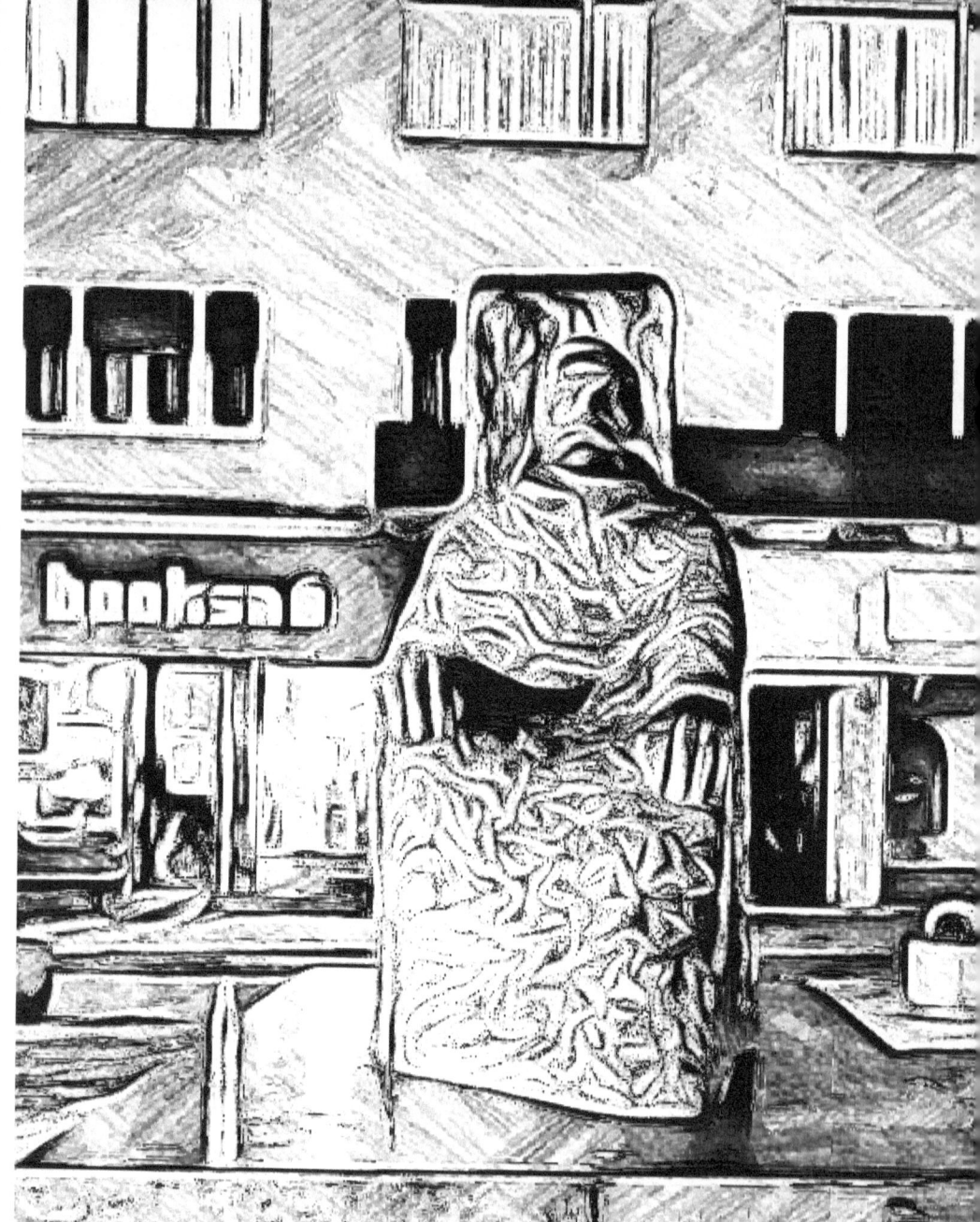

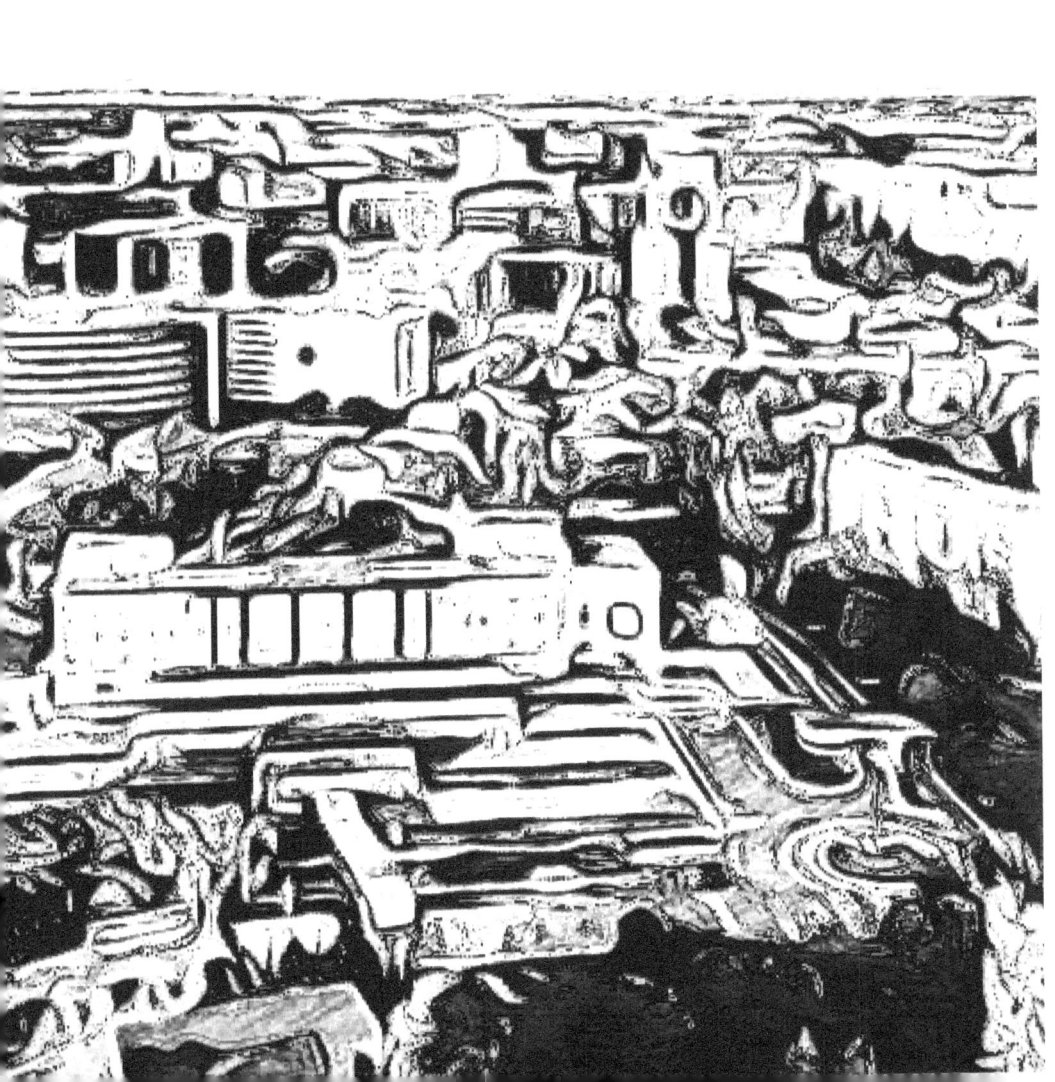

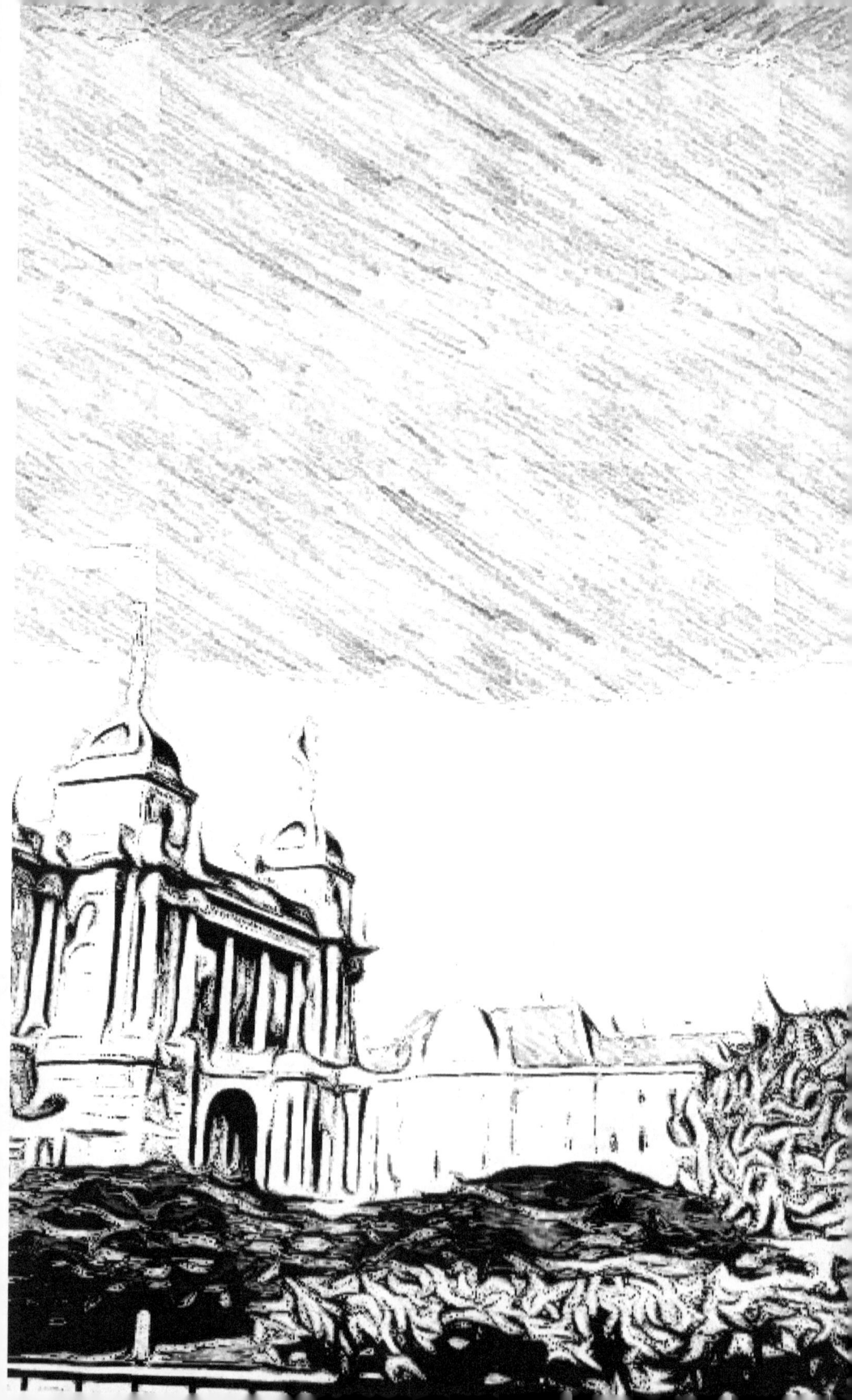

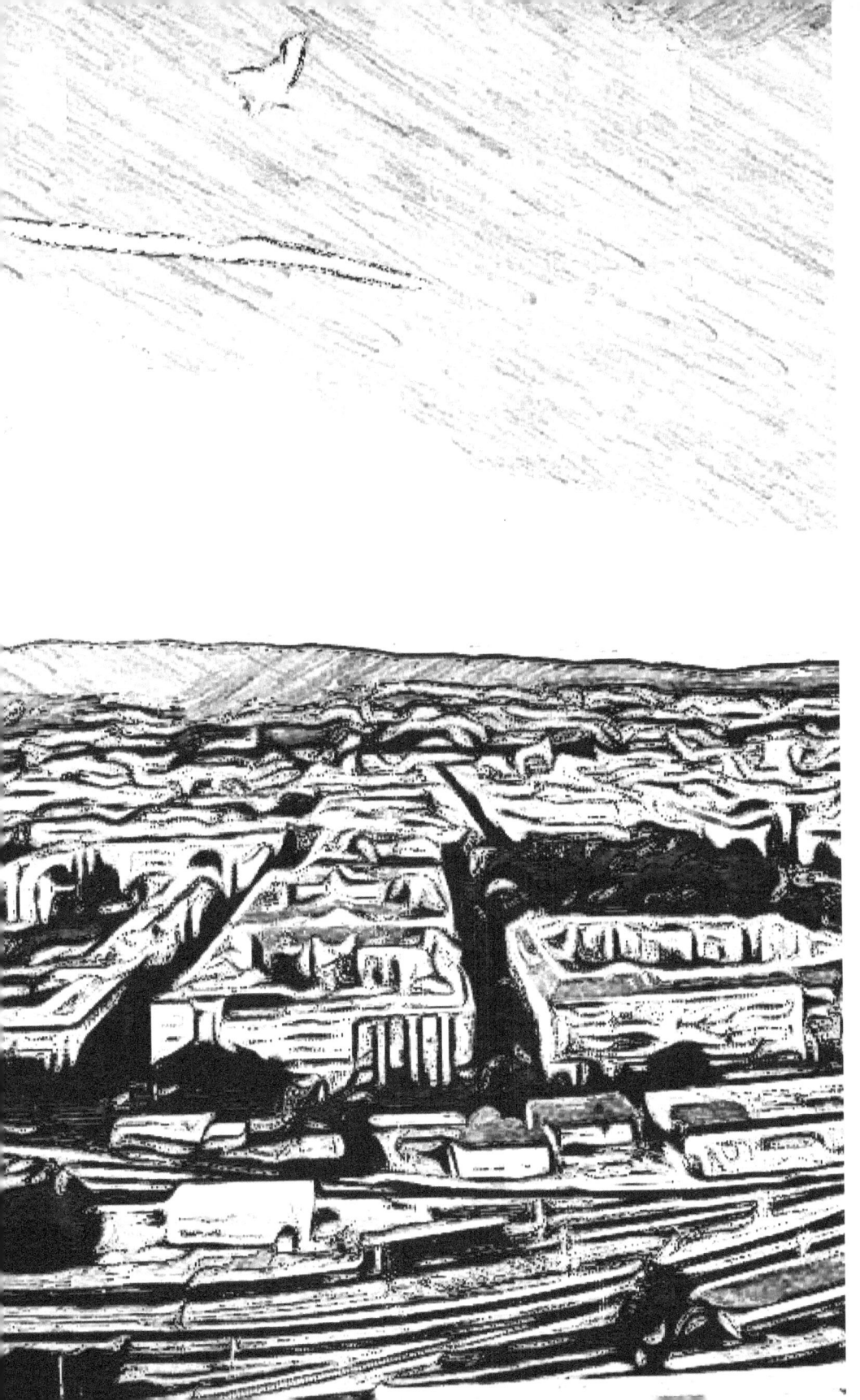

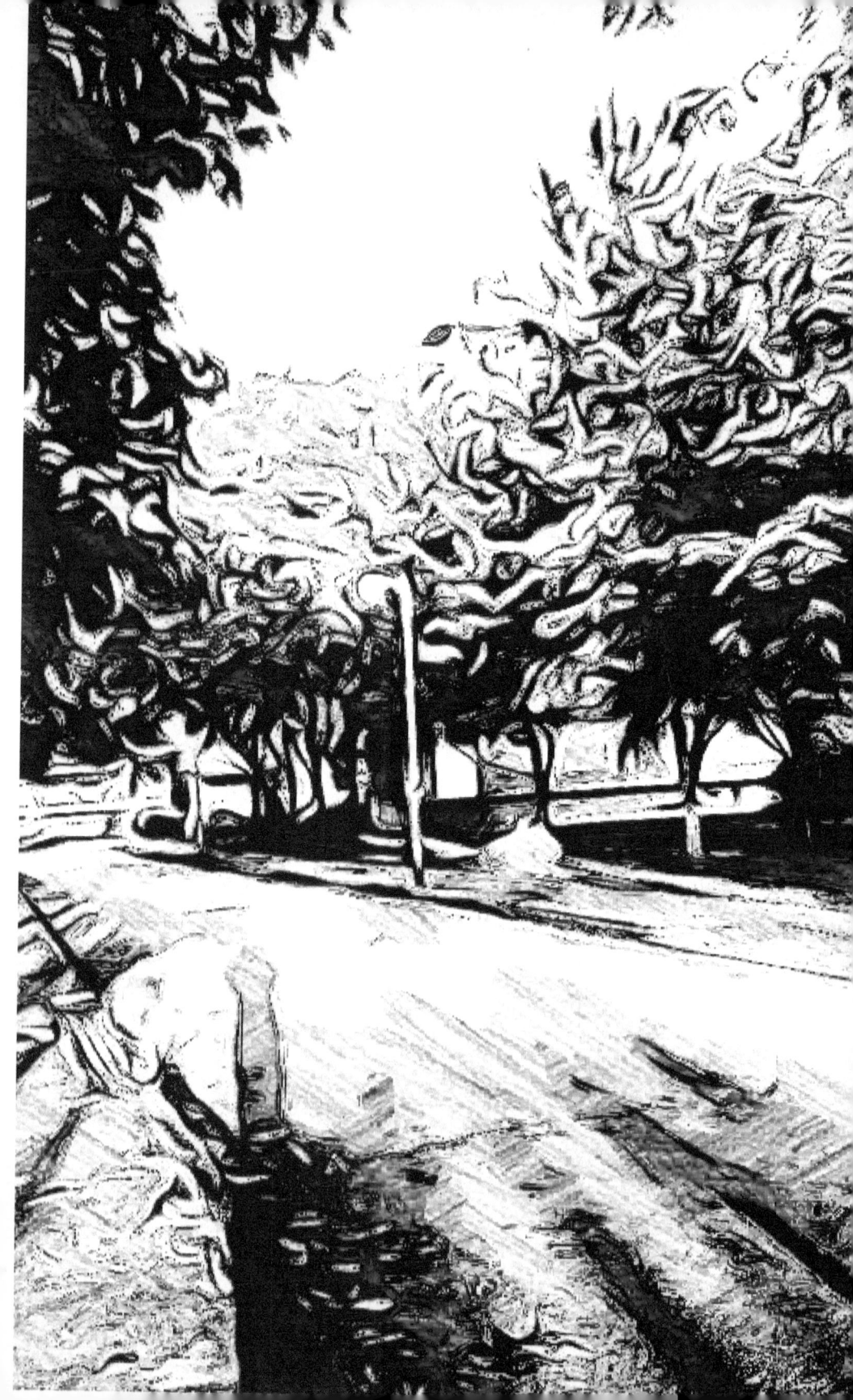

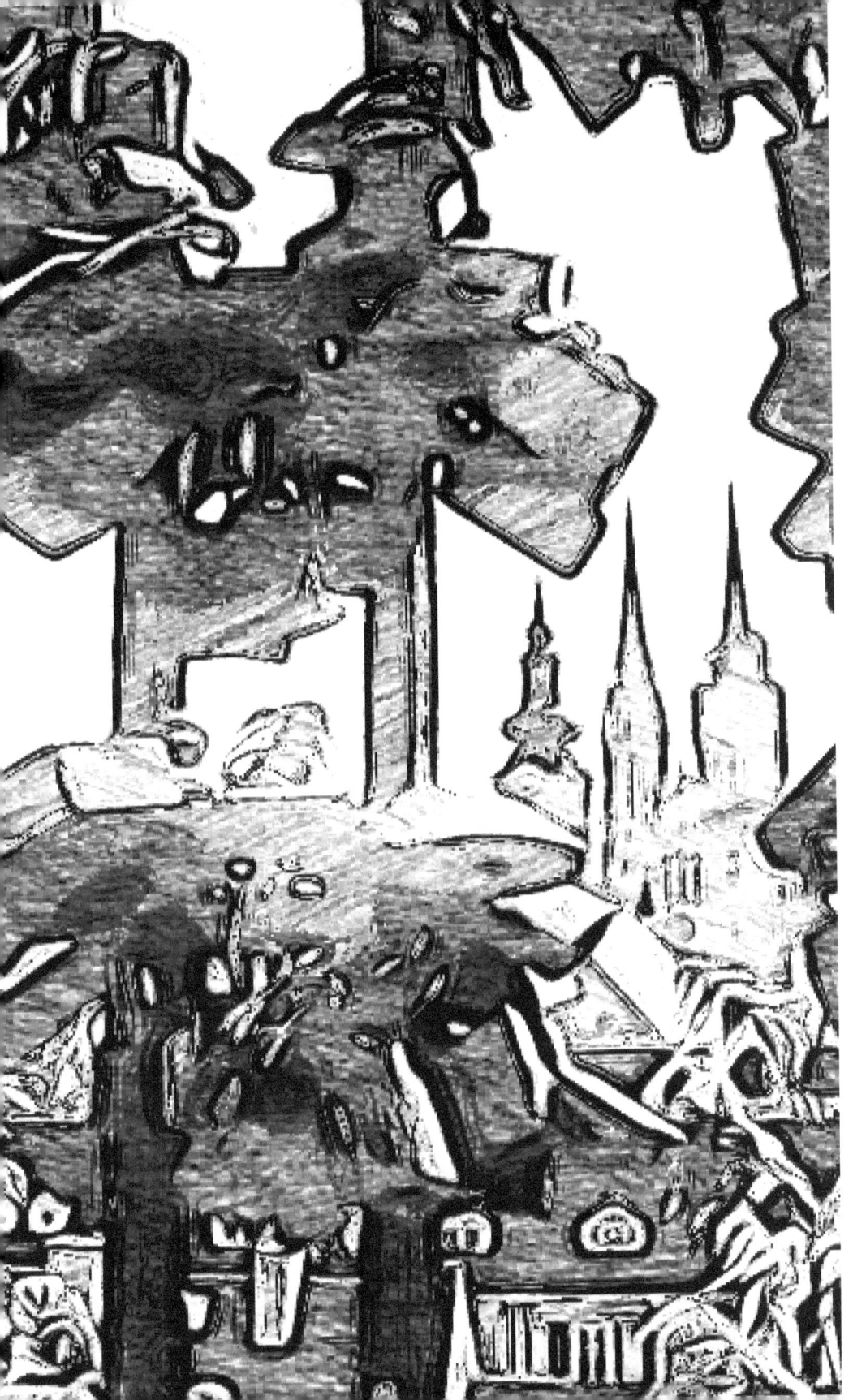

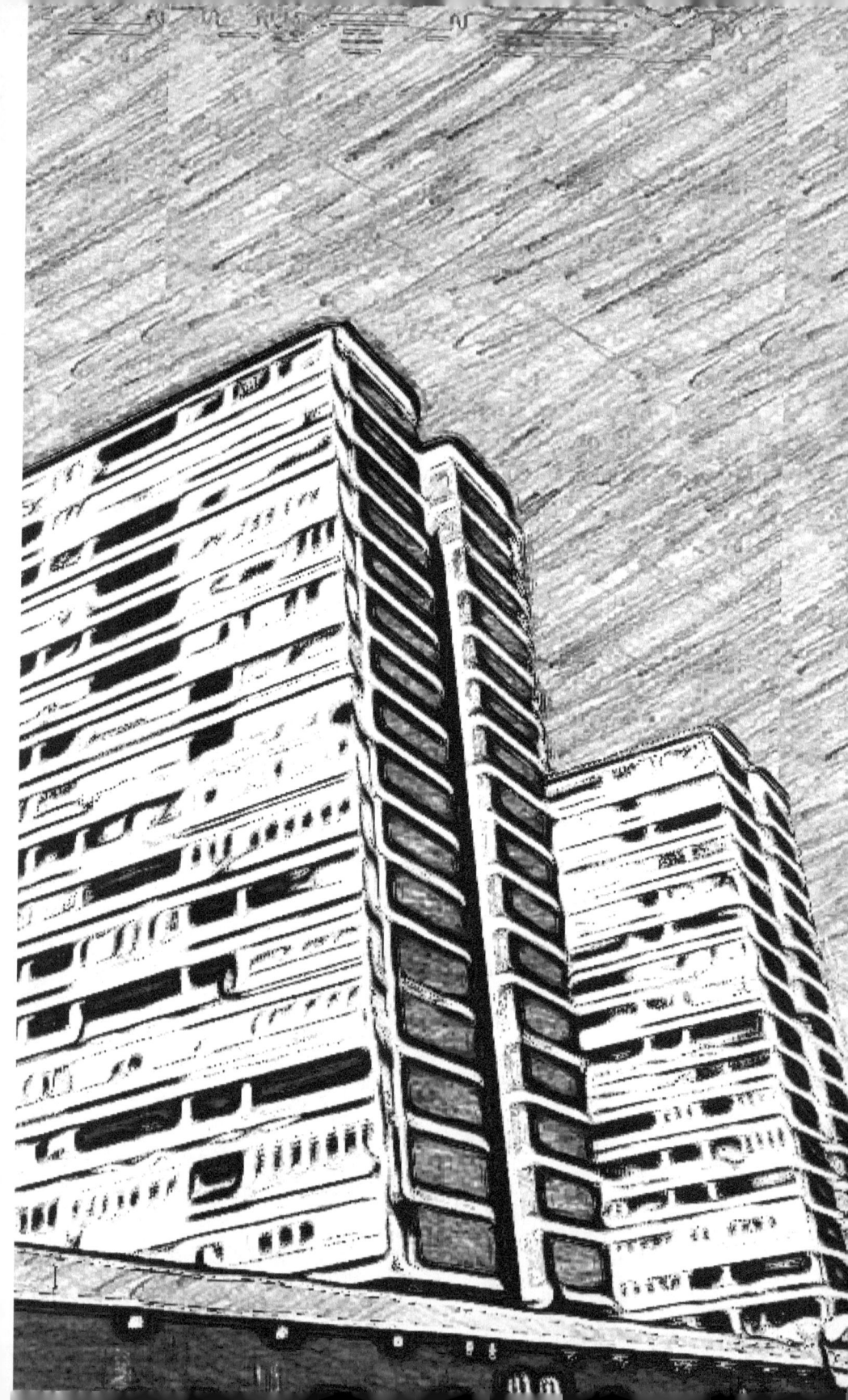

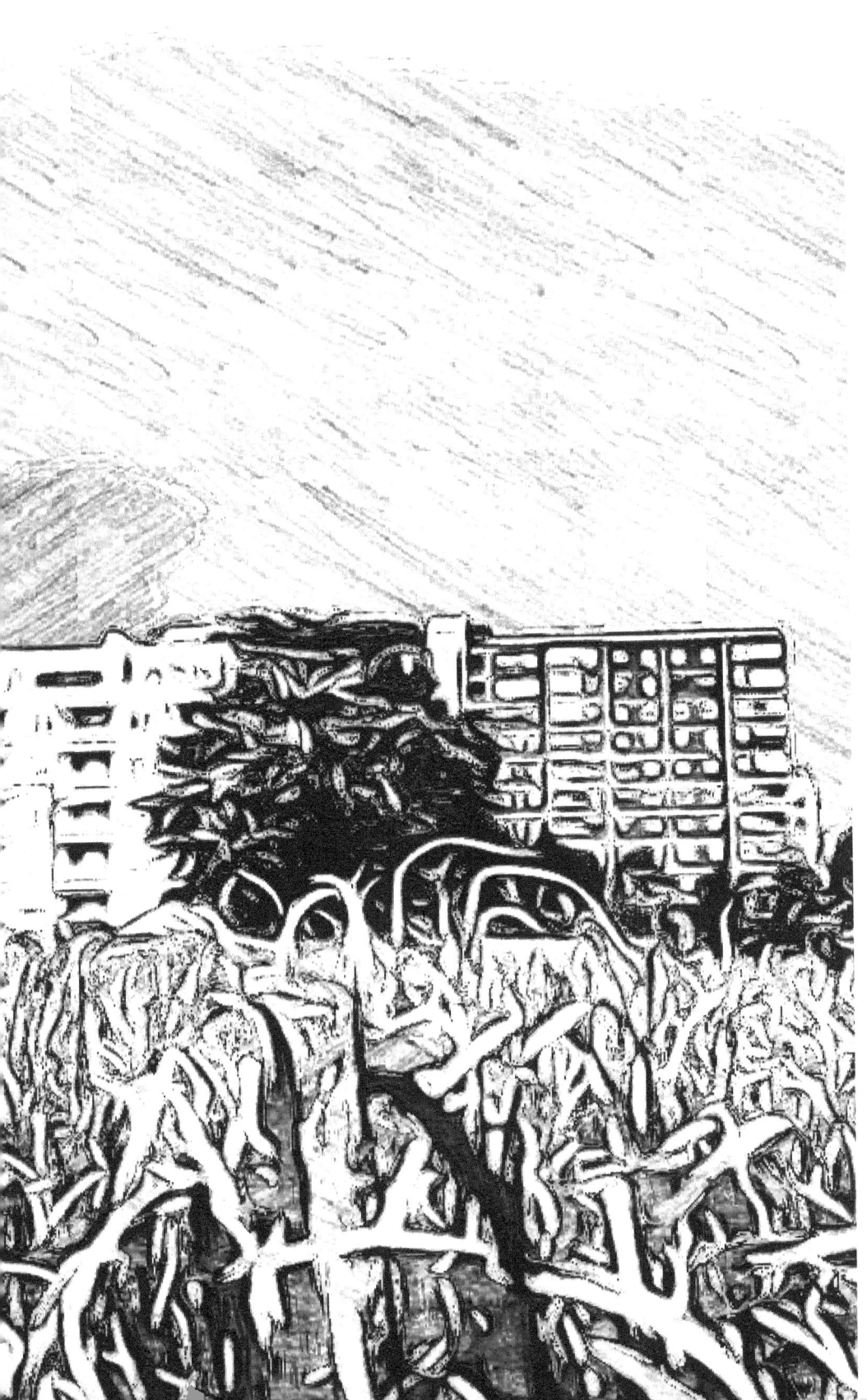

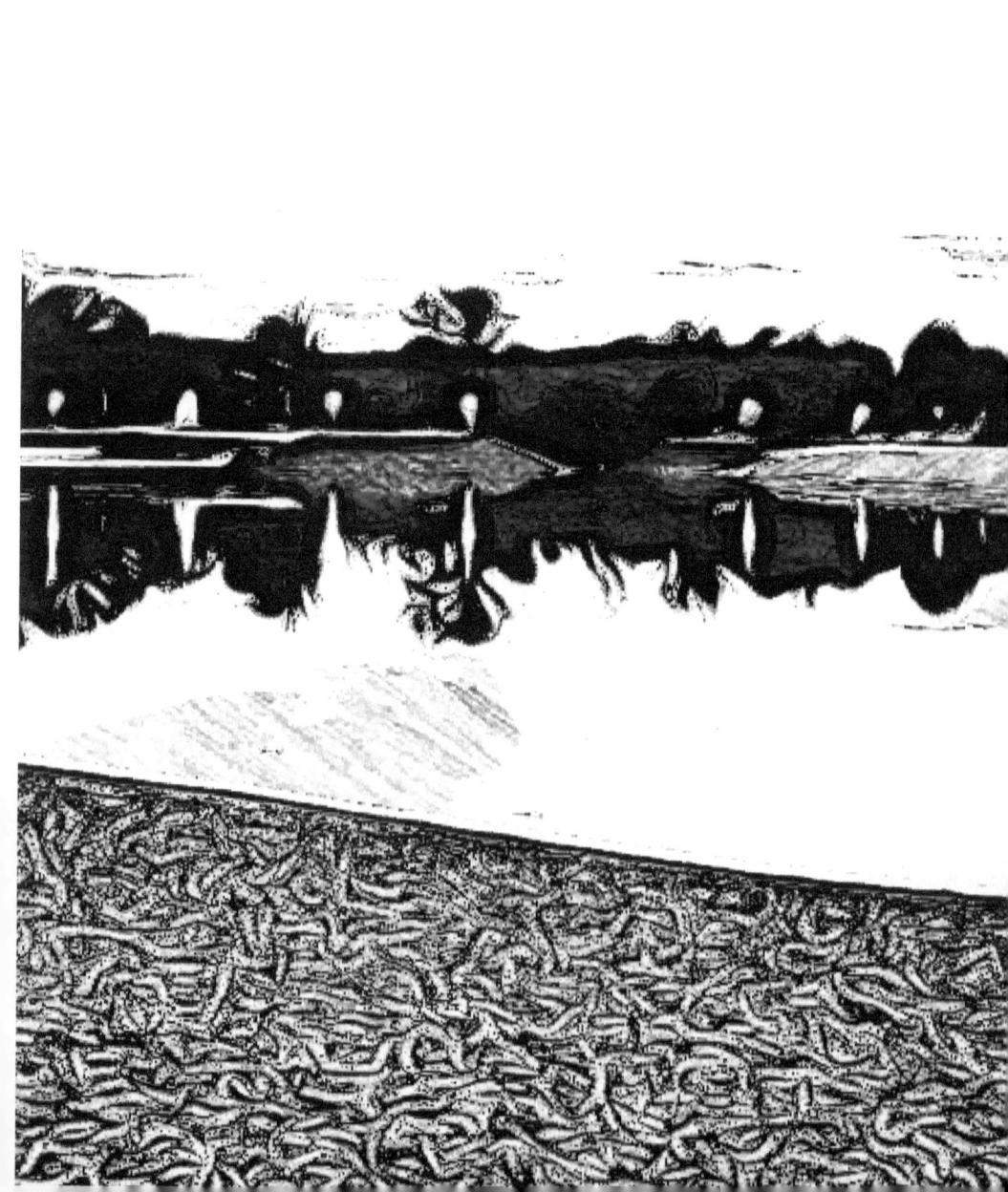

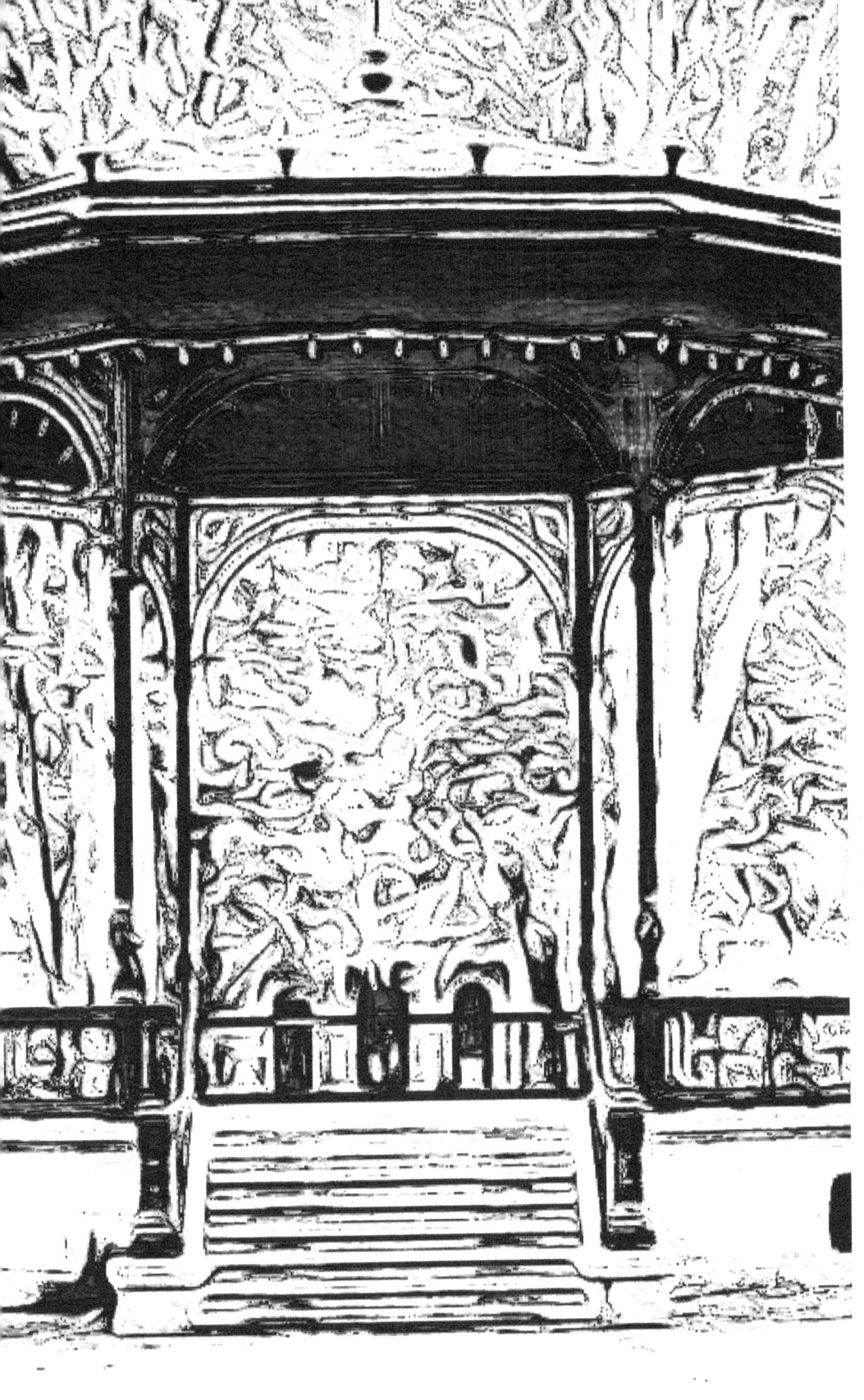

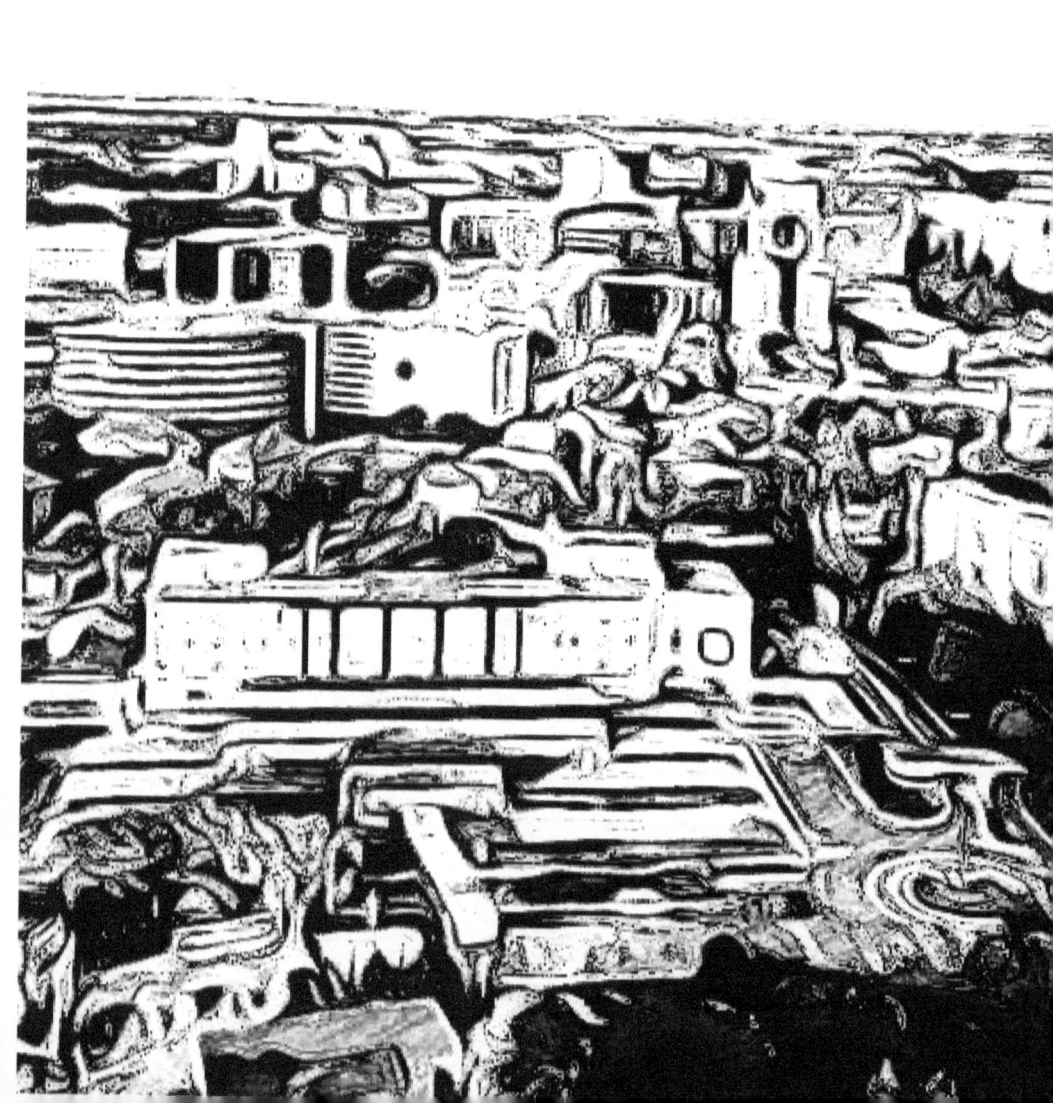

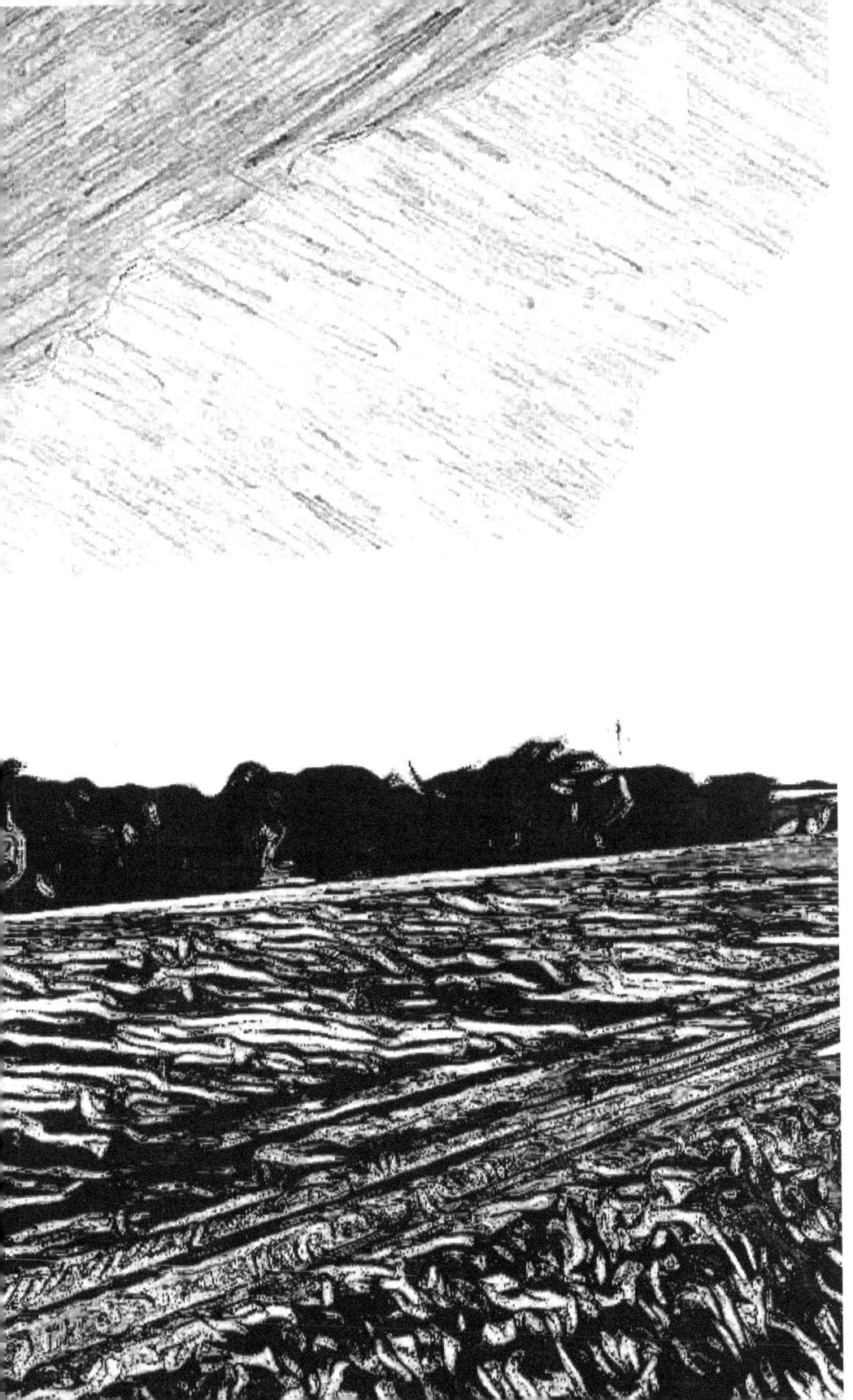

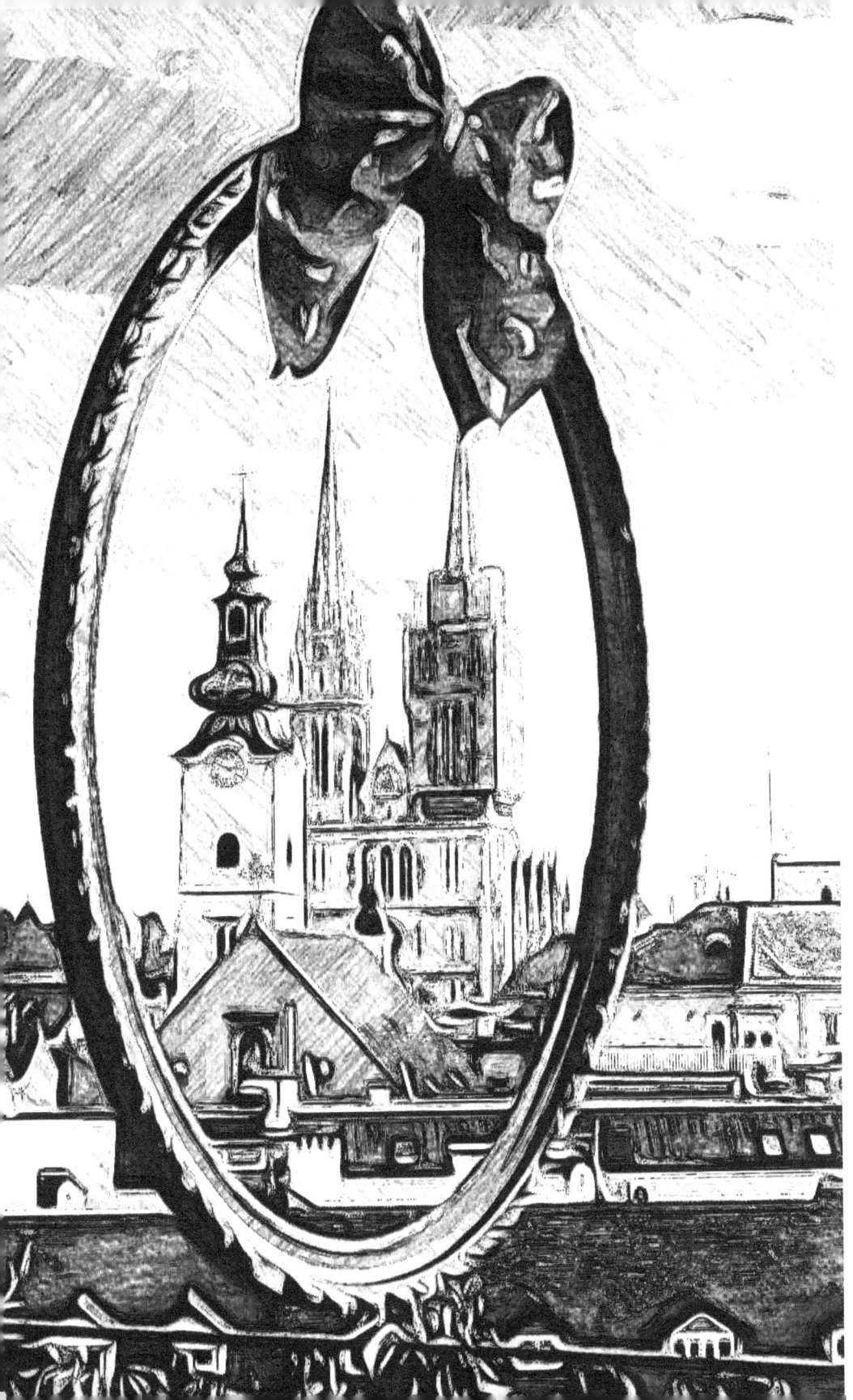

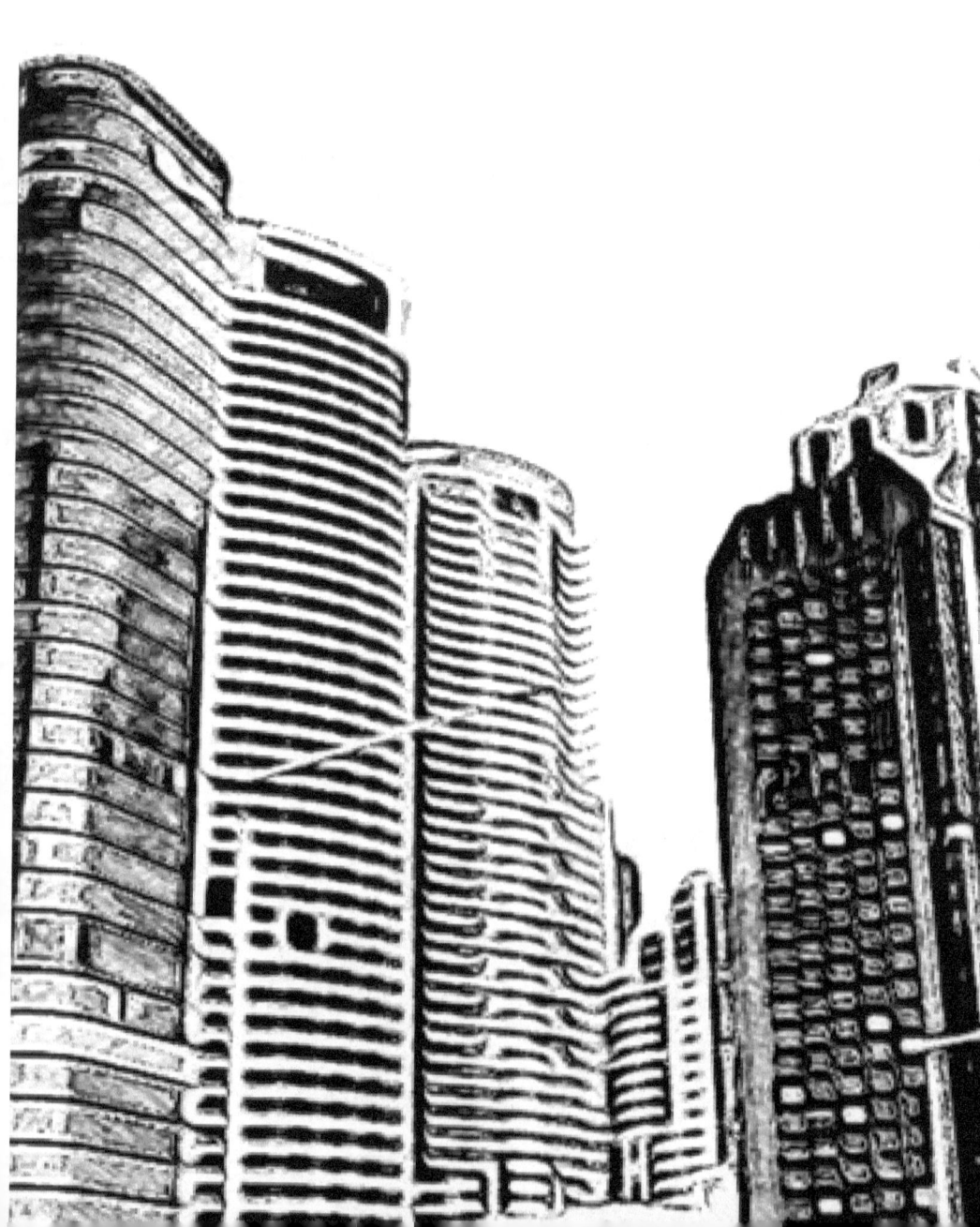

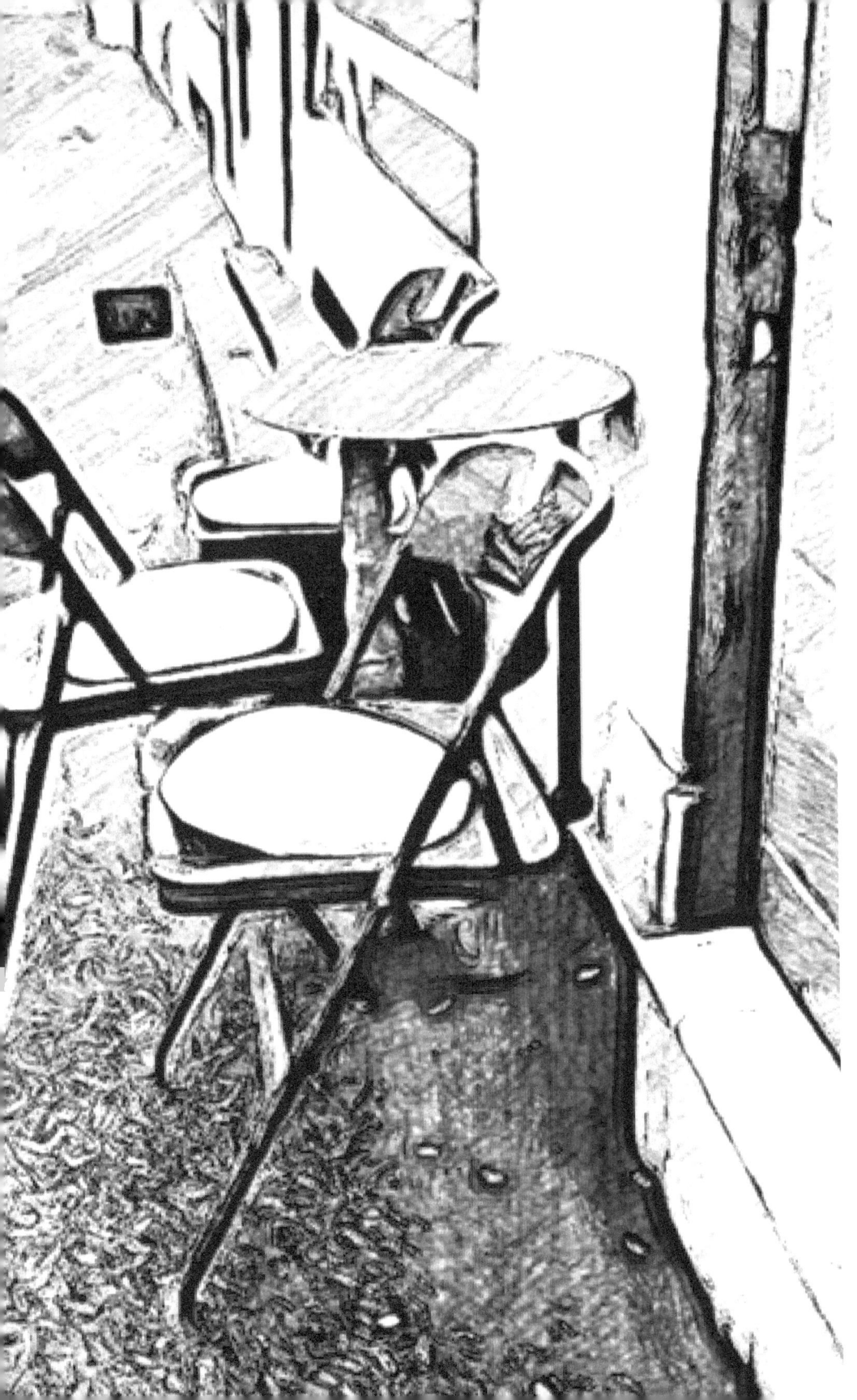

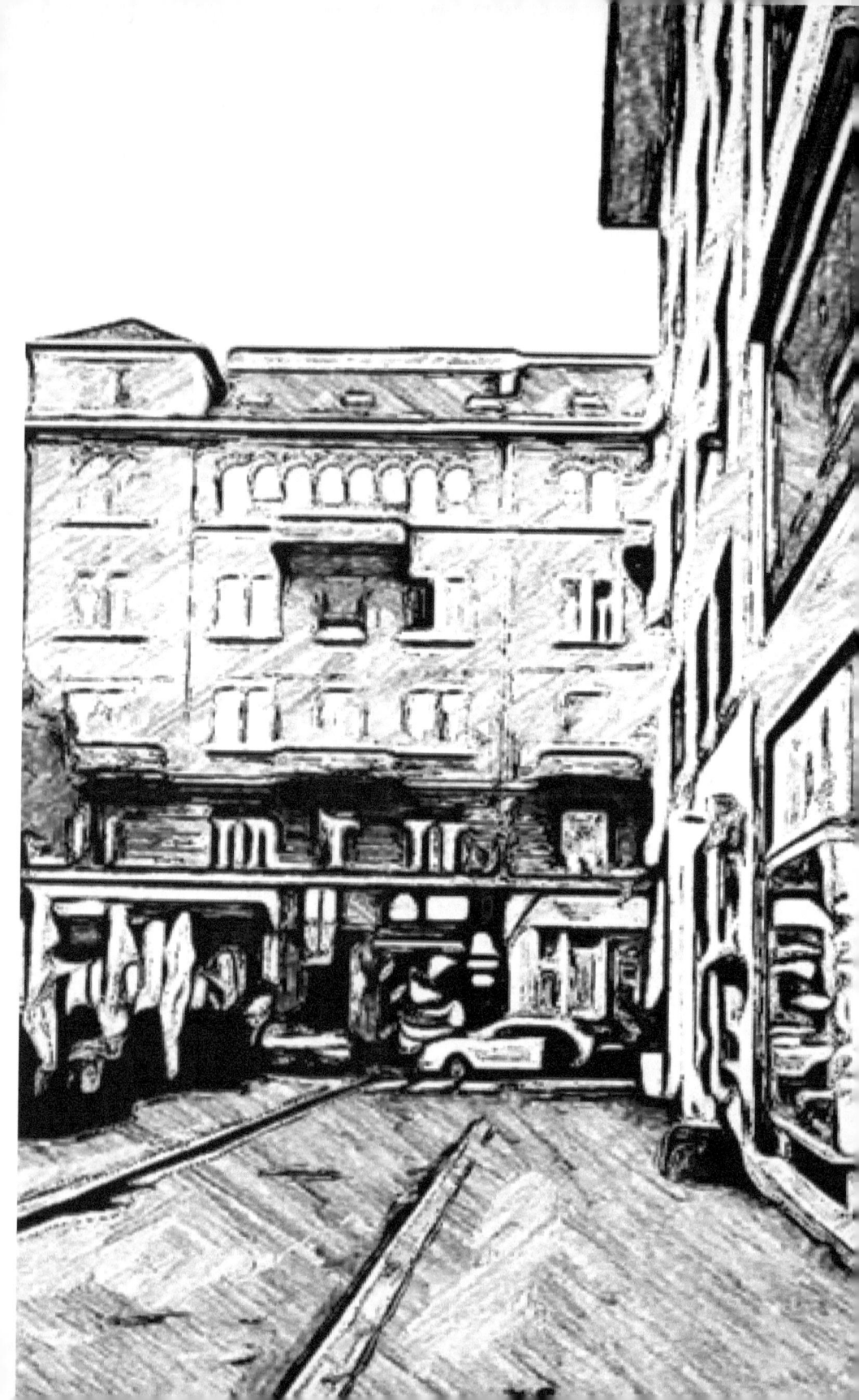

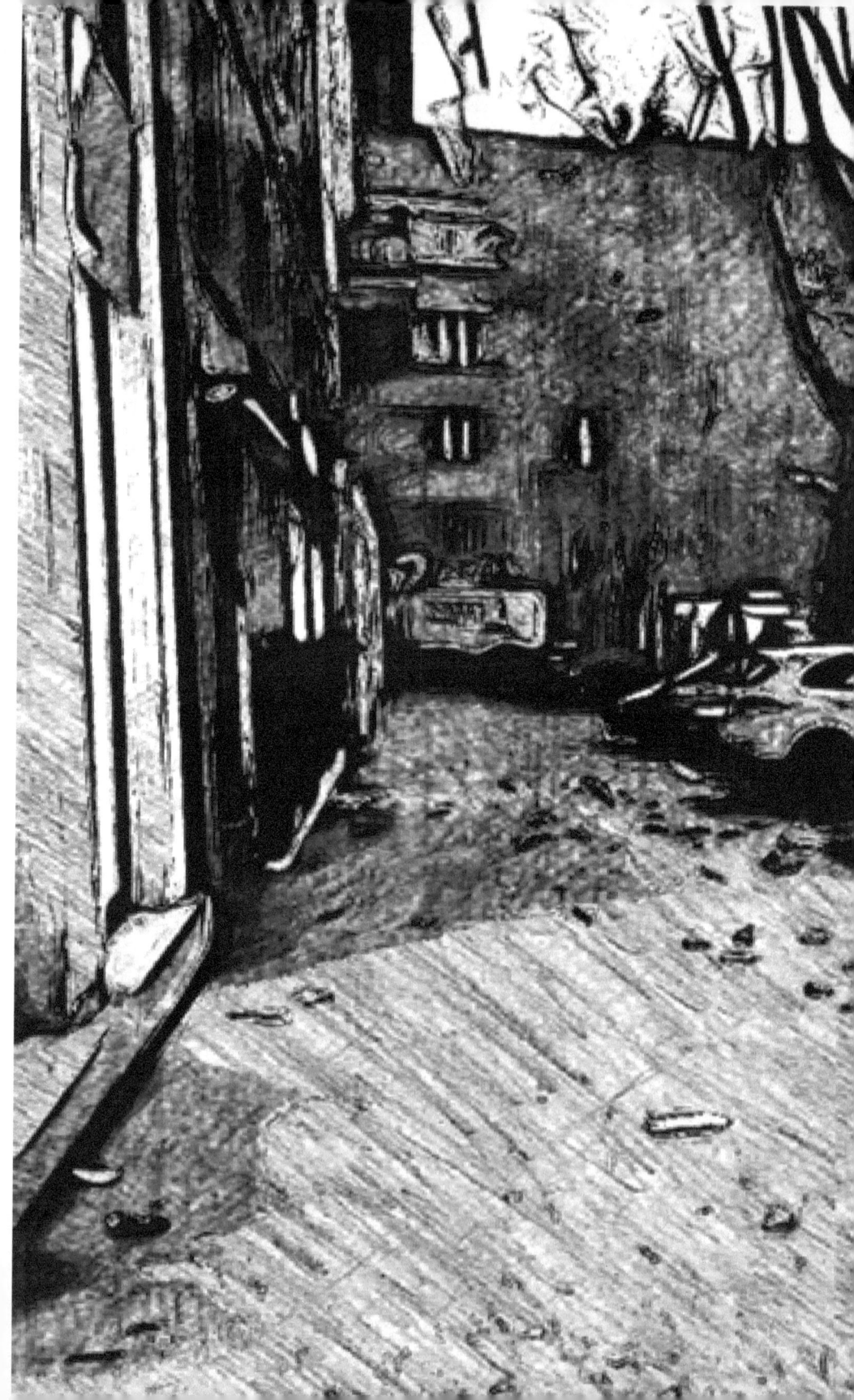

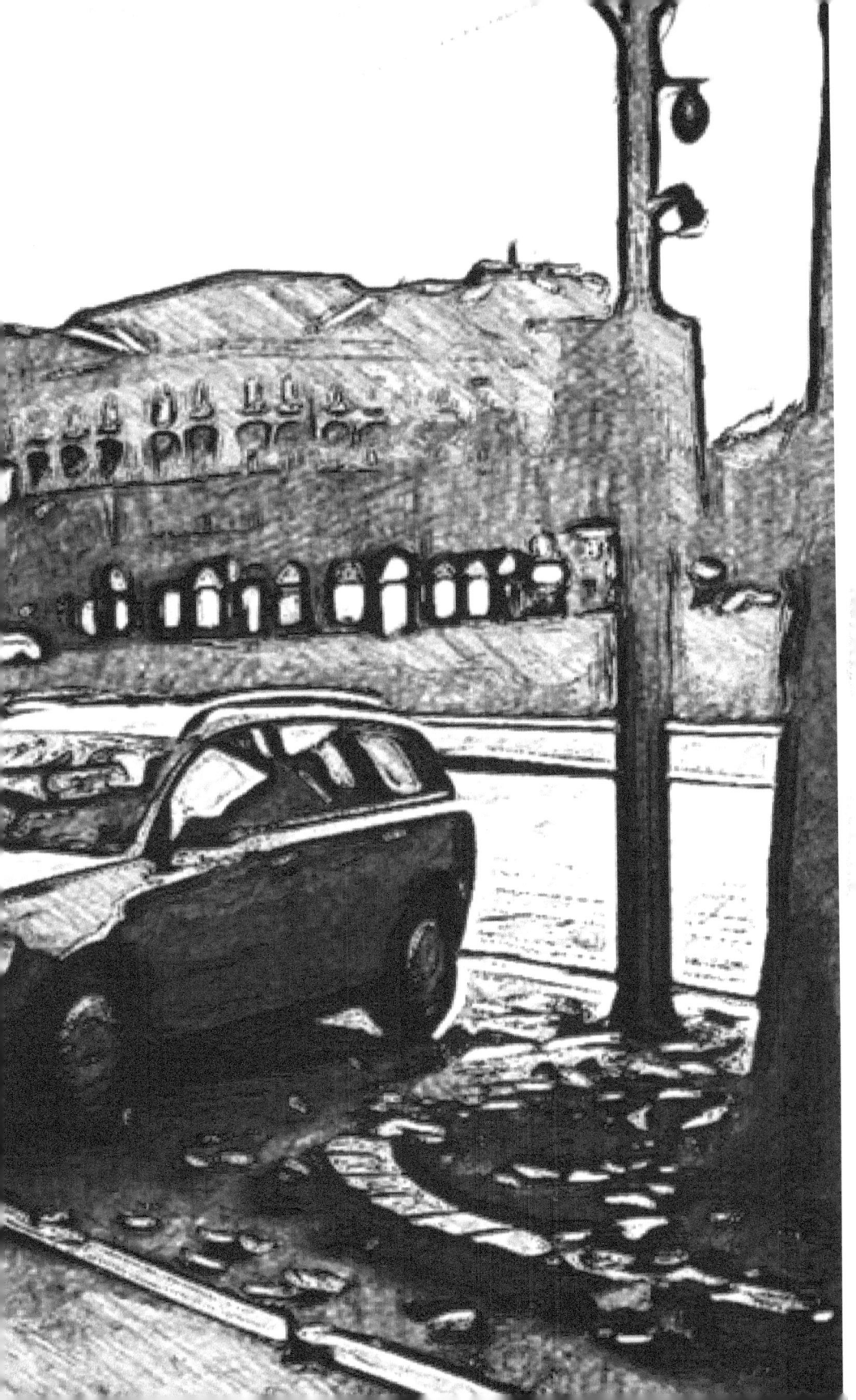

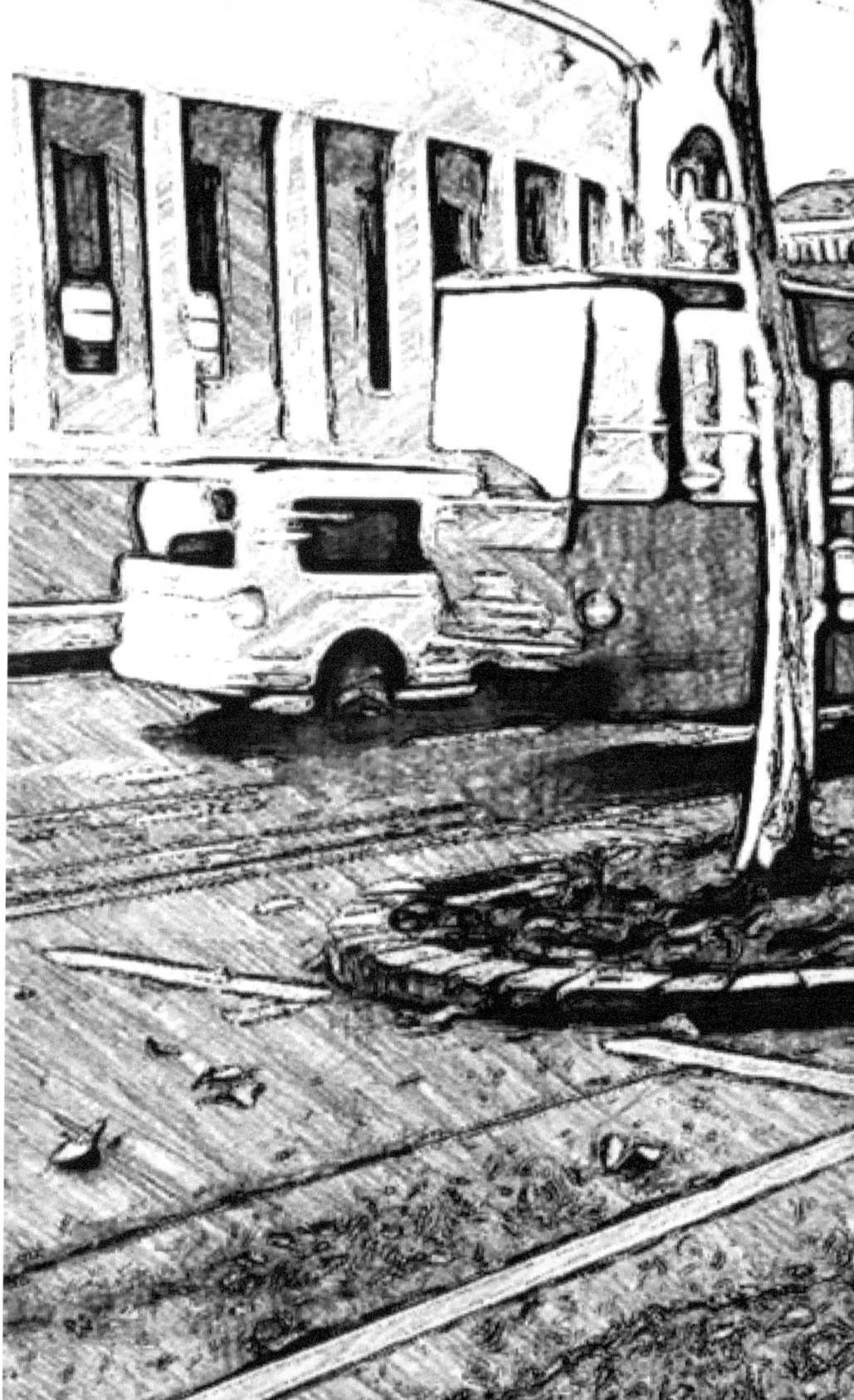

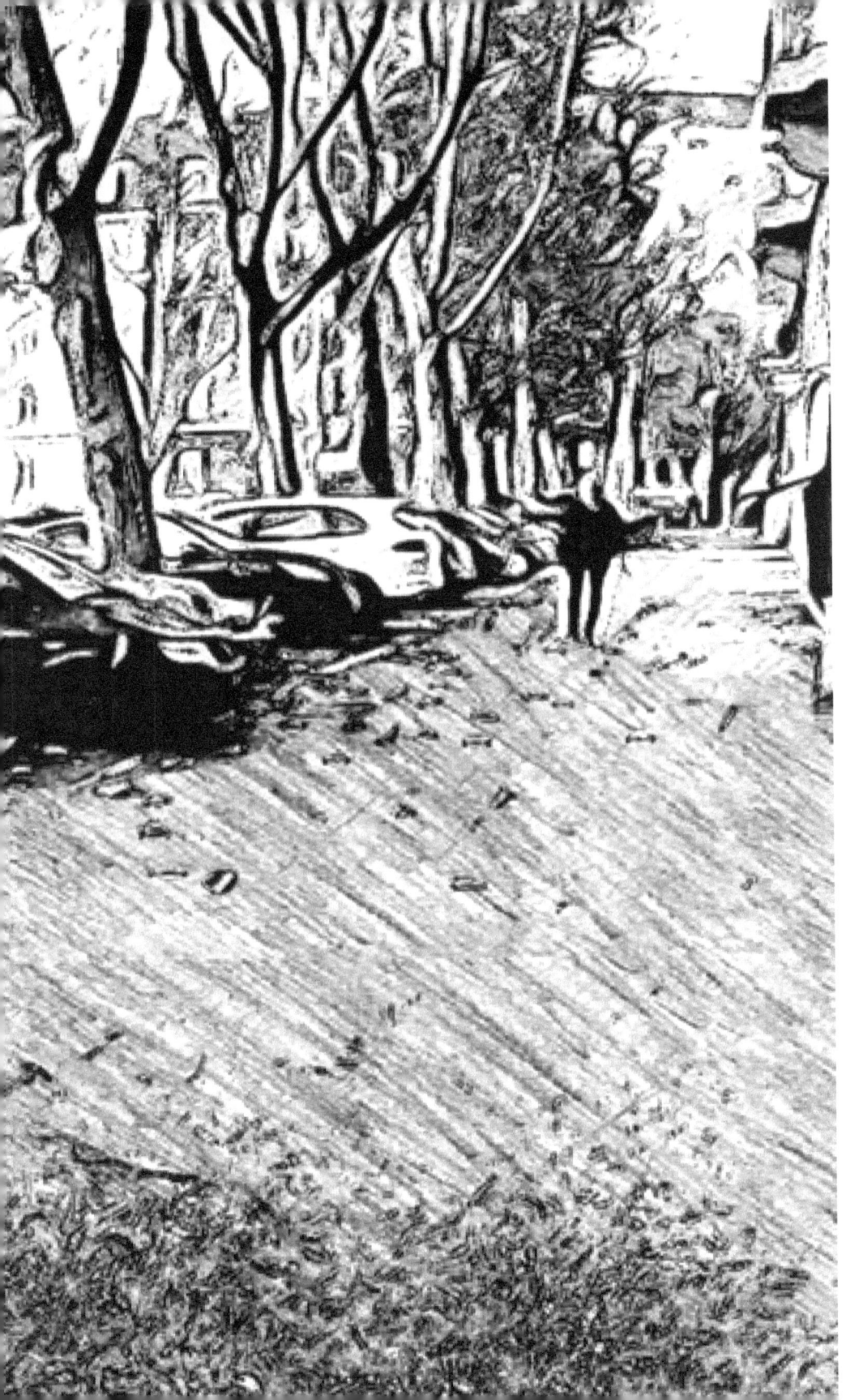

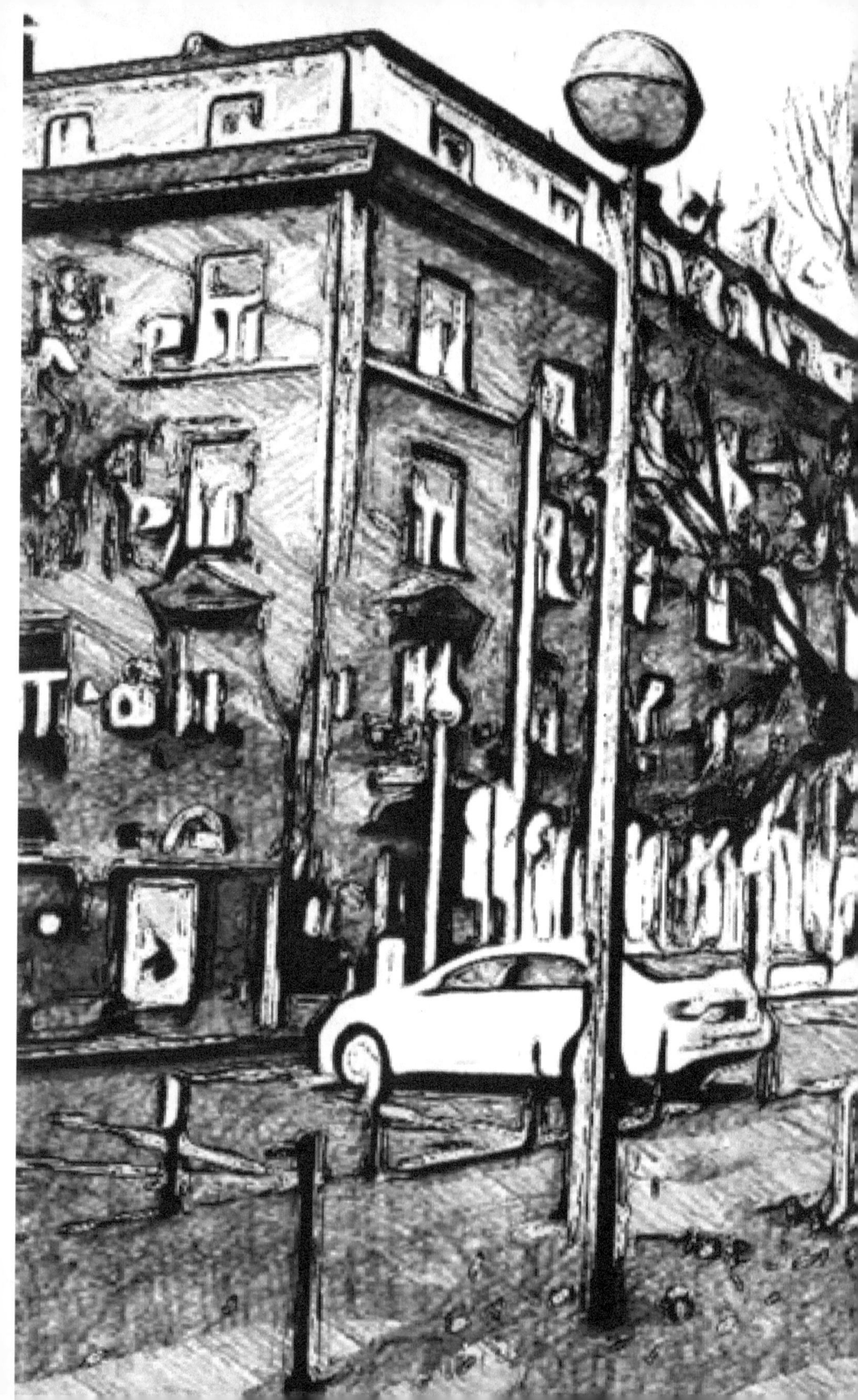

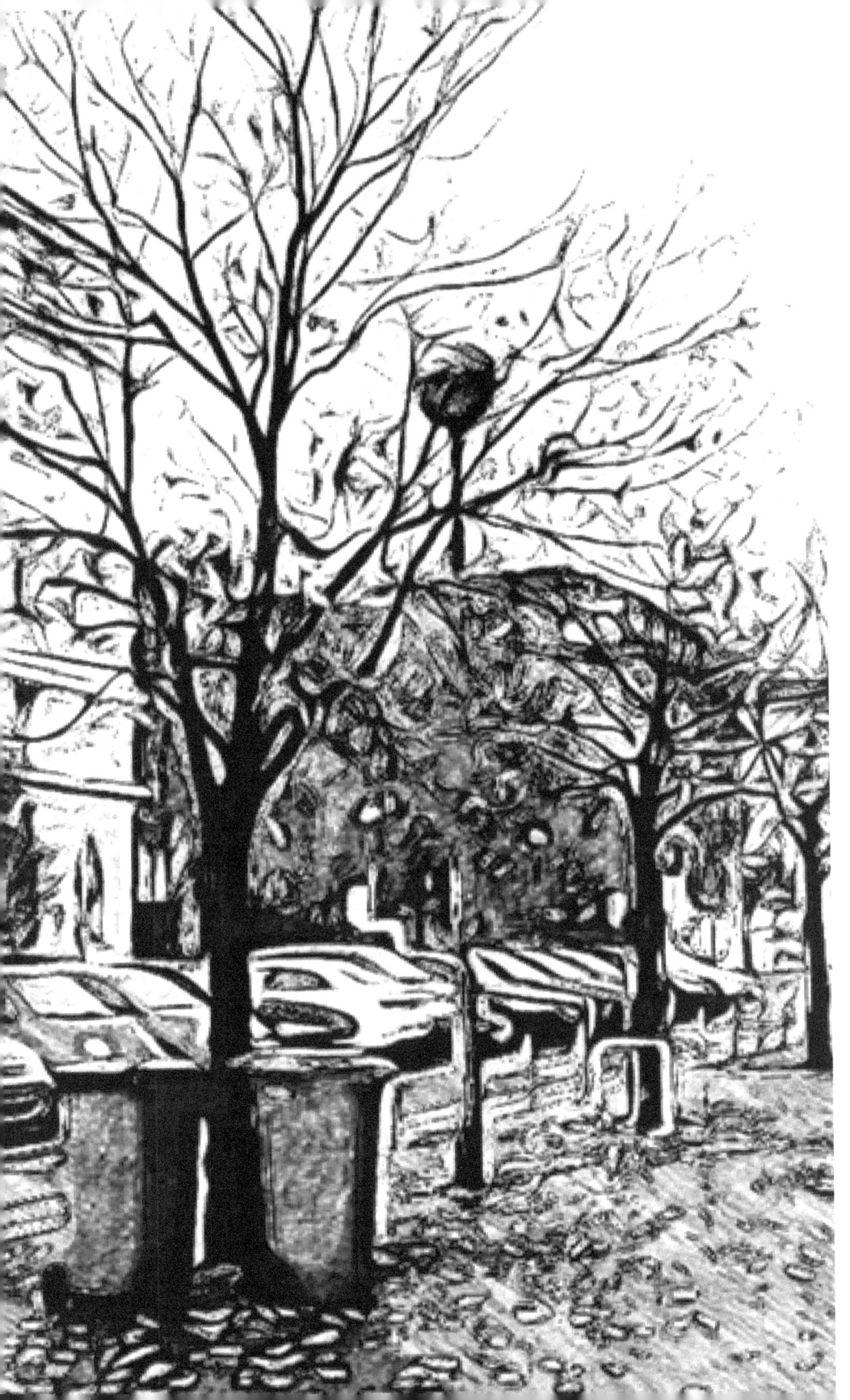

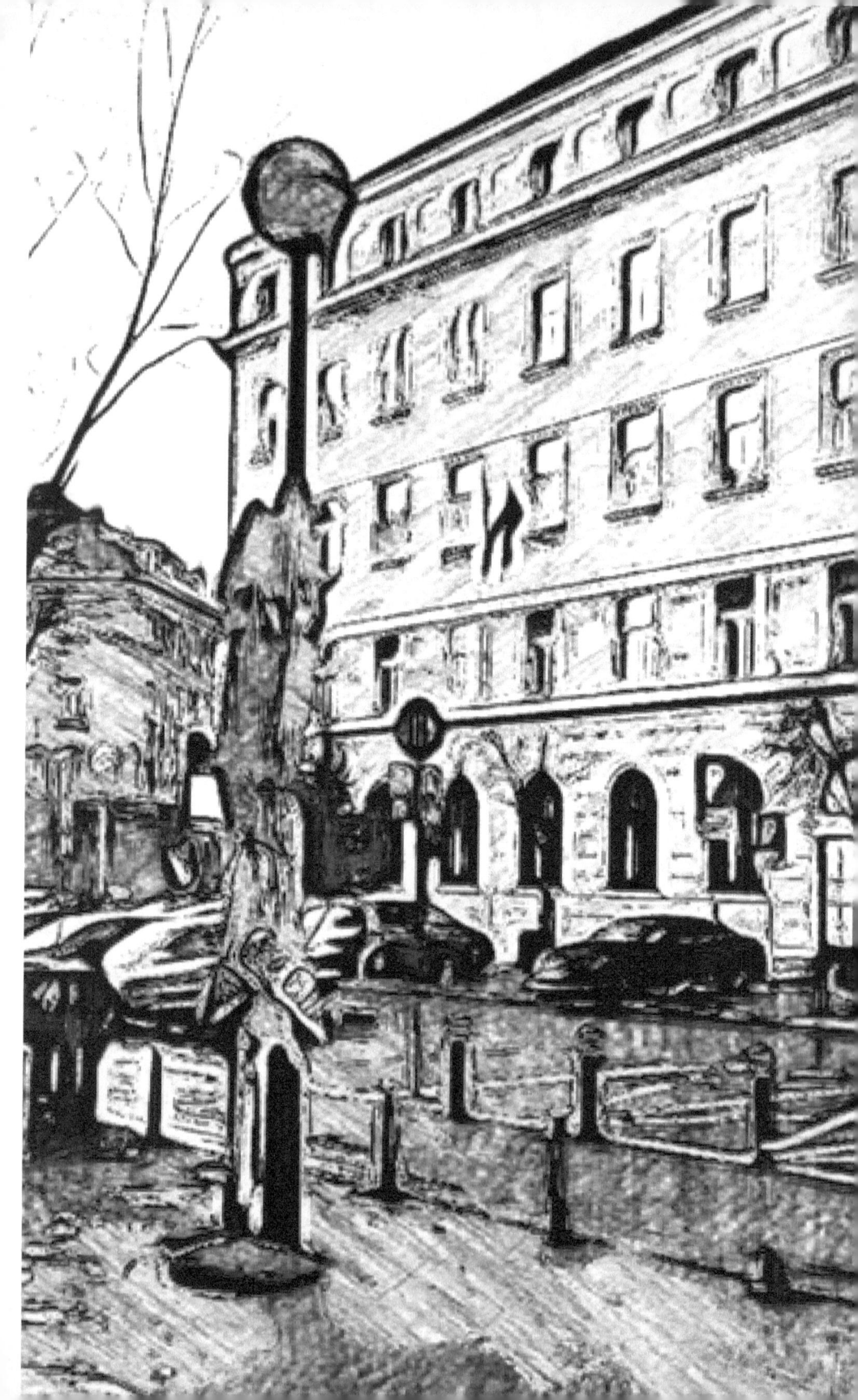

www.ingramcontent.com/pod-product-compliance
Lightning Source LLC
Chambersburg PA
CBHW030940240526
45463CB00015B/837